TRADITIONAL
COOKING

APULIA

FAVOURITE RECIPES

SiMEBOOKS

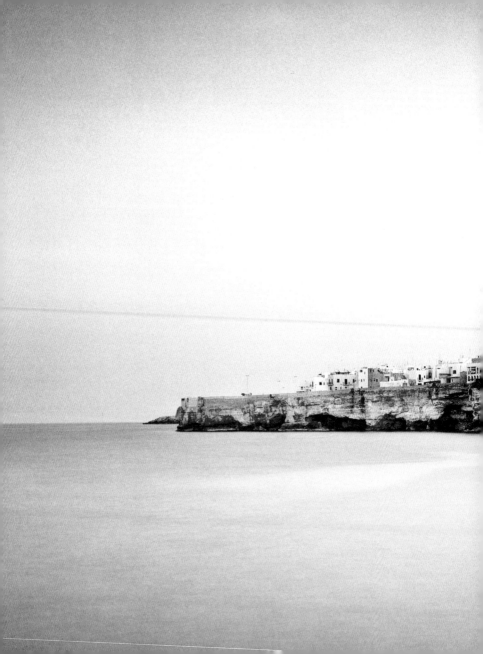

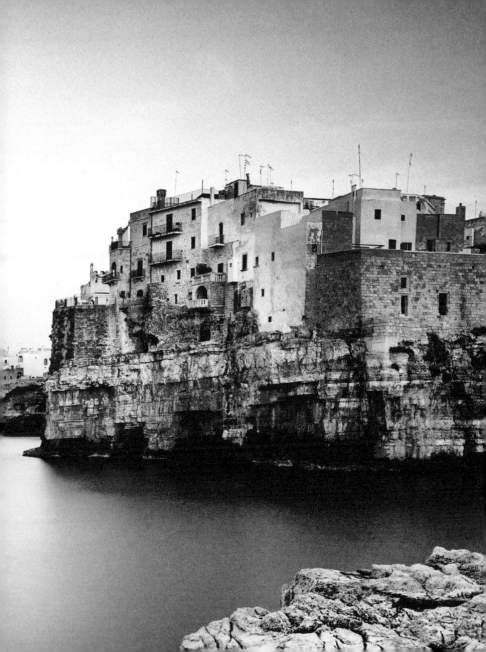

CONTENTS

Recipe difficulty:

■ ▢ ▢ easy

■ ■ ▢ medium

■ ■ ■ hard

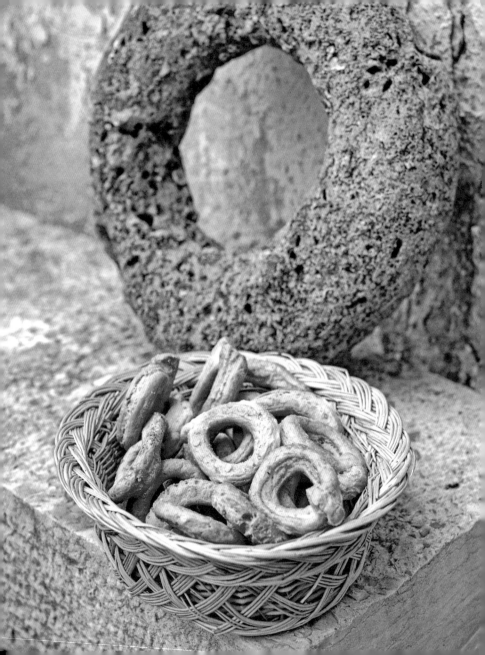

LOCAL SPECIALTIES

The cuisine of Puglia comes from both the land and sea. Its ingredients reflect the nature of the region, coming together in dishes that are 'simple' in the noblest sense of the world. The quality of these ingredients stems from farming and fishing traditions that are thousands of years old. And since so many of the dishes have the most humble origins, they are generally easy to prepare.

From the land
While Puglia produces a sizeable proportion of Italy's fruit and vegetables, what is really remarkable is their variety. There's barely a patch of Puglia that isn't planted with the very best the land can produce, and much of this produce has earned DOP (protected designation of origin) and IGP (protected geographical indication) certification as well as the Slow Food stamp of approval. Gourmets are always on the lookout for the region's produce, such as the sweet, juicy **clementines** grown around the Gulf of Taranto, the unique **Ferrovia cherries**, the delicate **red onions** from Acquaviva, the **fava beans** from Carpino, the **almonds** from Toritto, the **oranges** and **lemons** from Gargano, the **artichokes** from San Ferdinando... And it would be doing a great disservice to the

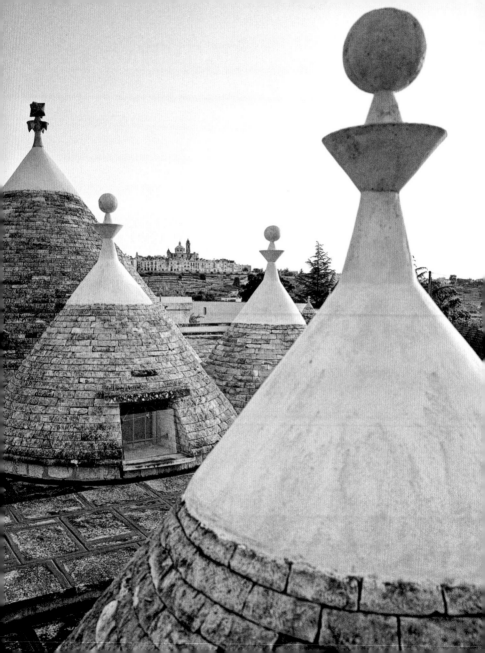

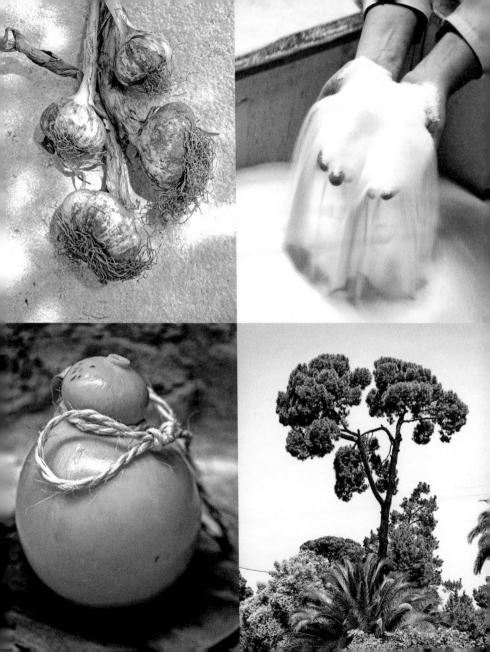

culinary tradition of the region not to also mention its **turnips**, tassel hyacinth bulbs, delicious **king oyster mushrooms**, **chicory**, the broccoli-like *mùgnuli*, table grapes, and the rare **Caroselli** and **Barattieri** cucumbers, which grow nowhere else in the country. And from peppers to courgettes, aubergines to artichokes, almost every vegetable is beautiful grilled or fried with a splash of olive oil, or preserved in oil in a hundred different ways. Of course, olives are part of the way of life here, like the famous Bella della Daunia variety, which is preserved in brine (the green ones) and used in appetizers and fried (the black ones). It's a short step from olives to olive oil, and Puglia produces some of the finest in Italy, with no fewer than five oils with DOP (protected designation of origin) certification and production that places it among the first in the world both quantity and quality.

And the sea
Occupying a strip of land between the Adriatic and Ionian Seas, much of Puglia's culinary richness comes from the sea.
Black mussels from the Gulf of Taranto have been famous since antiquity, while nowadays

the **prawns** from Gallipoli and the **eels** from Lake Lesina are equally famous. Caught more or less throughout the region, Puglia's seafood – razor clams, sea urchins, bearded horse mussels, oysters, Venus clams, baby squid... – are sometimes eaten raw as appetizers, with nothing but a squeeze of lemon.

Close to the grain

The Tavoliere Plain, Italy's 'grain store' in northern Puglia, supplies a large portion of the wheat eaten in the country. And bread and baked products are cornerstones of the Puglia diet, reaching the highest levels of quality and including curiosities like *grano arso* or 'burnt wheat'. The **bread** baked in Altamura, Monte Sant'Angelo and Laterza is famous throughout the country, eaten fresh as an accompaniment to meals but also old as the basis for **bruschetta** and **acquasale**. But Puglia is also synonymous with **panzerotti**, **focacce**, **friselle**, **taralli**, **tarallini**, **scaldatelli**, **pucce**, **uliate** and **pìttule** – an infinite number of ways to combine flour with simple, tasty ingredients. The region is also the southernmost bastion of polenta, which is eaten here in fried cubes called *sgagliozze*. But the undisputed king of the table is **pasta**, which has as many different

names as there are shapes. Orecchiette reign supreme here, but pasta sauces and vegetables also go perfectly with **strascinate, troccoli, cavatelli, sagne 'ncannulate, minchiareddhri**...

A dairy treasure chest
What's Puglia's most famous cheese? Definitely **mozzarella**, which is made by stretching curd into balls, braids and knots. But who can resist a delicious piece of **burrata**, with its core a mixture of stretched-curd cheese and cream. It is difficult to find your way around the galaxy of cheeses made in Puglia: **cacio, caciocavallo, cacioricotta, pecorino, ricotta** and **scamorza** are made more or less everywhere in the region. Some areas have had their names linked to their finest cheeses, such as burrata, **caciocavallo silano, canestrato pugliese** (with DOP, protected designation of origin certification) and **caciocavallo podolico dauno**. Milk is also used to make three of the region's culinary gems: **manteca**, with its heart of butter wrapped in a stretched curd; **giuncata**, a fresh cheese with a delicate flavour; and **ricotta** skuant, a strong and spicy cheese.

Meat and cold cuts

Sausages and meat in Puglia tend to have strong flavours. **Faeto prosciutto** is dark, while the **capocollo from Martina Franca** is delicious. An unforgettable dining experience is to eat at one of the *fornelli pronti* (butcher shops that also cook what they sell) in Valle d'Itria and Laterza, where they serve grilled meat as well as lamb and goat offal rolls known as **turcinieddhi** (and in some places gnumerieddhe). The **salamis from Alta Murgia** and the **sausages from Salento** are also known for their strong flavours. **Horsemeat** is also widely eaten here, as chops and in stews, as are **lamb** and **goat**, either roasted or grilled.

ANTIPASTOS AND FOCACCIAS

16

Antipastos
and focaccias

Serves 4:
- 4 friselle barley
 bread rings
- 4 ripe red tomatoes
- 2 garlic cloves
 oregano
- extra virgin olive oil
- salt

BARLEY BREAD WITH TOMATO

Rub the garlic into the bread.

Dampen the bread under cold running water, being careful not to soak it too much.

Rub tomato into the bread and season with oil, salt and oregano.

Optionally top with fresh rocket and grated hard ricotta cheese.

Amure
Salento IGT Bianco
Cantine Emera,
Guagnano (Lecce)

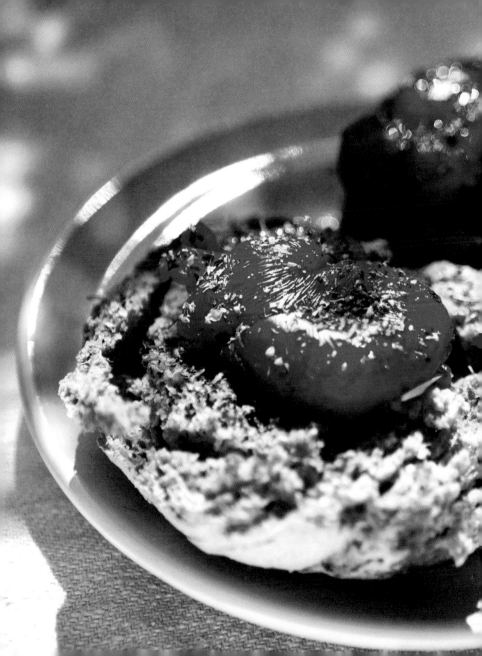

AUBERGINES IN OIL

Ingredients:
- aubergines
- garlic cloves
- a few fresh
 peppermint
 leaves
- chilli pepper
- extra virgin olive oil
- white wine vinegar
- coarse salt

Wash the aubergines then remove the top and bottom. Peel and cut into fairly wide slices or strips.

Place in a bowl of water and vinegar for a few minutes, remove and thoroughly squeeze dry.

Layer in a flat-bottomed wide-mouth jar, making a layer of the garlic, peppermint, pepper and coarse salt every 2 or 3 layers of aubergines.

Using a weight, press the finished layers as much as possible for at least 24 hours.

Remove the water by carefully upending the jar, ensuring that the aubergines do not move.

Keeping the weight in place, add the white wine vinegar and, after 2 or 3 hours, drain again. Then cover completely with oil.

Ready to be eaten after a month.

FOCACCIA BARI STYLE

Ingredients for a
medium focaccia:
- 125g (1¼ cups) flour
- 125g (¾ cup)
 semolina
- 1 medium potato
 (approx. 125g or
 4 ½ oz)
- 12.5g (2 tsps)
 brewer's yeast
- ½ tsp sugar
- small tomatoes
 (plum or cherry)
- oregano (optional)
- 1 level tsp fine salt
- coarse salt
- extra virgin olive oil

Boil the potato. Allow to cool then mash.

Mix the flour, semolina and salt with the
mashed potato. Knead by hand until
thoroughly mixed.

Place approximately 120ml (½ cup) of
lukewarm water in a bowl, crumble in the
yeast and add the sugar. Mix thoroughly.

Combine the two mixtures and knead.
Add water until the dough is soft and sticky.

Oil a medium oven tray and put in the dough,
flattening it with wet hands until it covers
almost all the tray (the remaining space will be
filled when it rises) and is approximately 1cm
thick.

Cover well and allow to rise for at least an
hour without disturbing. Look to see that it
has risen properly.

Once the dough has risen, cover completely
with the chopped tomatoes.

Sprinkle with plenty of oil, a little coarse salt
and, if desired, oregano.

Bake in a preheated oven at 180-200°C
(360-390°F) for 25-30 minutes.

ACQUASALE BREAD

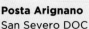

Serves 4:
- 4 slices old bread
- 200g (7 oz) fresh
 tomatoes
- 1 red onion
- 1 garlic clove
- 1 tsp oregano
- a few basil leaves
- extra virgin olive oil
- salt

Quarter the tomatoes.

Chop the onion and garlic.

Place the slices of bread on a plate and cover with tomatoes, chopped onion and garlic, basil, oregano, salt and a drizzle of olive oil.

Serve after approximately 30 minutes.

Posta Arignano
San Severo DOC
Bianco - Cantine
D'Alfonso del Sordo,
San Severo (Foggia)

MARINATED ANCHOVIES

Serves 4:
- 1kg (2 ¼ lbs) fresh anchovies
- 2 glasses white wine vinegar
- 1 small bunch Italian parsley
- garlic
- extra virgin olive oil
- salt

Wash the anchovies. Bone and head them, then open without separating the two sides.

Wash under running water and pat dry with a cloth.

Marinate in vinegar and salt, refrigerating for approximately 2 hours.

Drain and rinse. Season with chopped garlic and parsley, chilli pepper (optional), and drizzle with oil.

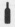

Bolina
Salento IGT Bianco
Cantine Rosa del
Golfo, Alezio (Lecce)

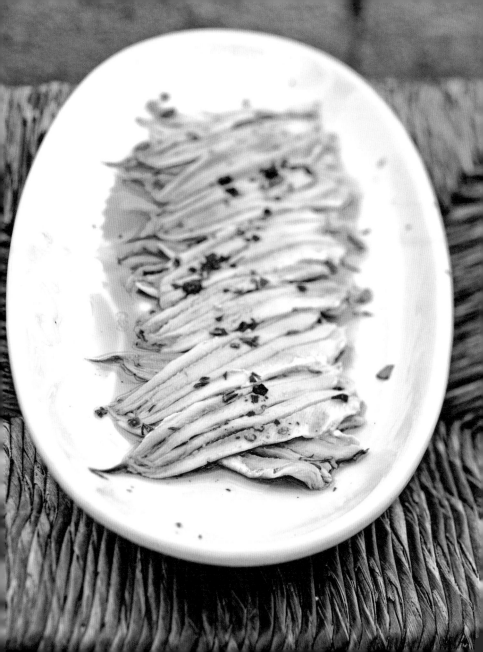

DOUGH FRITTERS

Serves 4:
- 500g (5 cups) flour
- 12.5g (2 tsps)
 brewer's yeast
- extra virgin olive oil
- salt

Dissolve the yeast in a little lukewarm water.

Make a well in the flour and add the yeast and a pinch of salt, mixing with lukewarm water to soften the mixture.

Knead until the ingredients are thoroughly combined and leave to rise for approximately 3 hours under a towel in a warm place.

If desired, add some boiled cauliflower, baccalà (dried salted cod), or a mixture of anchovies, olives and cherry tomatoes to the dough.

Form the fritters using a spoon and fry in a pan with ample hot oil. Remove when golden brown and puffed up.

Drain off the excess oil and leave to dry on kitchen paper.

Sprinkle with salt and serve hot.

Ingredients:
- 400g (4 cups) flour
- 20g (1 tbsp)
 brewer's yeast
- 8 cherry tomatoes
- mozzarella cheese
- extra virgin olive oil
- salt
- pepper

FRIED PIZZA
DOUGH POCKETS

Prepare the dough by mixing the flour with
the brewer's yeast, diluted in a little water,
and a pinch of salt.

Using a rolling pin, roll the dough into several
approximately 12cm wide circles.

Cook the tomatoes separately.

On one half of each dough circle, arrange
the sliced mozzarella, tomato sauce, salt and
pepper.

Fold over to form a semi-circle, sealing the
edges carefully.

Fry in ample very hot oil and remove only
when fully browned.

Drain then absorb the excess oil on kitchen
paper. Serve hot.

SWEET-AND-SOUR FISH GALLIPOLI STYLE

Ingredients:
- 1kg (2¼ lbs) small fish (e.g. whitebait)
- 250mg (⅛ tsp) powdered saffron
- flour
- breadcrumbs
- extra virgin olive oil
- 1l (2 pts) white wine vinegar

Thoroughly clean the fish, dip in flour and fry in a pan with ample hot oil.

In a bowl, dissolve the saffron in the vinegar. Wet the breadcrumbs in the mixture.

Arrange the fried fish in layers in a bowl, interspersed with the moistened breadcrumbs, filling to the top edge.

Allow to marinate for a few days before serving.

Cappello di Prete
Salento IGT Rosso
Cantine Candido,
San Donaci (Brindisi)

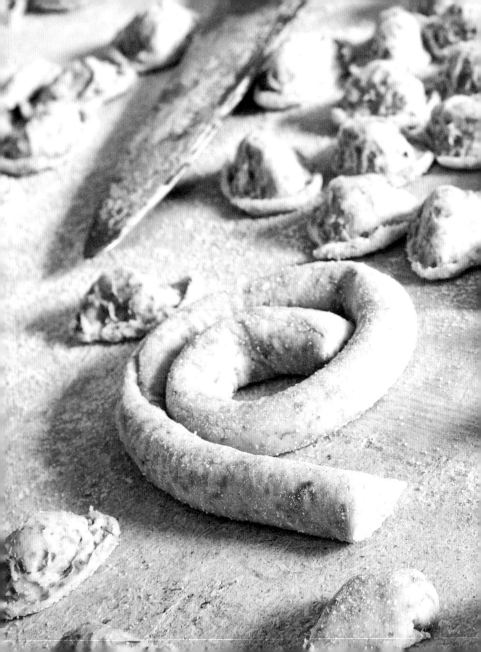

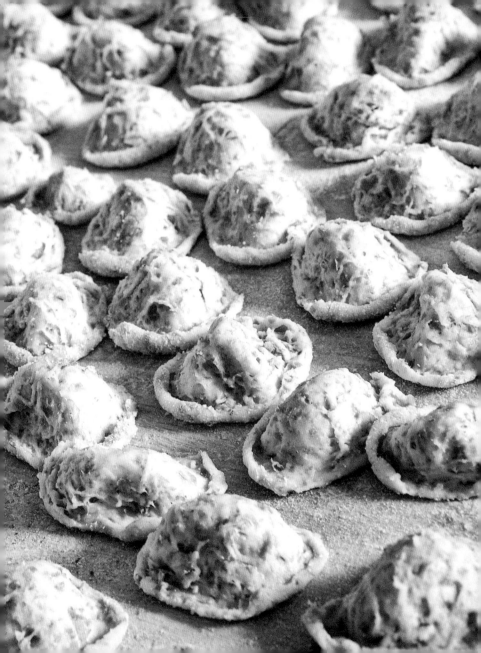

FIRST COURSES

ORECCHIETTE PASTA WITH BROCCOLI RABE

Serves 4:
- 300g (11 oz) fresh orecchiette pasta
- 300g (11 oz) broccoli rabe
- garlic
- chilli pepper
- anchovy fillets
- breadcrumbs (optional)
- extra virgin olive oil
- salt

Immerse the cleaned broccoli rabe in boiling salted water.

After approximately ten minutes, add the orecchiette pasta to the same water and cook together for a further 10 minutes. Drain well.

Separately, in a large frying pan, fry the fresh garlic with the chilli pepper, a few anchovy fillets and, if desired, plenty of breadcrumbs.

When the garlic is golden, add the orecchiette pasta and broccoli rabe and fry for a few minutes.

Serve with a drizzle of olive oil.

Gazza Ladra
Puglia IGT Bianco
Azienda agricola Santa
Lucia, Corato (Bari)

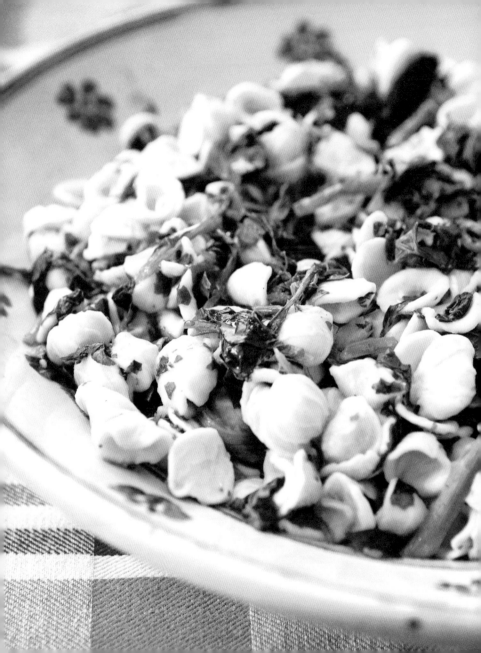

Serves 4:
- 320g (11¹/₄ oz) spaghetti
- 120g (4 oz) sea urchins
- 1 garlic clove
- 1 handful Italian parsley
- extra virgin olive oil
- salt

SPAGHETTI WITH SEA URCHINS

Boil the spaghetti in salted water until *al dente* then drain, retaining some of the cooking water.

Meanwhile, soften the garlic in oil in a frying pan.

Toss the pasta in the garlic and oil, adding a few tablespoons of the cooking water, then add the sea urchin roe and stir for 1 minute.

Sprinkle with finely chopped parsley.

Girofle
Salento IGT Rosato
Azienda Monaci,
Copertino (Lecce)

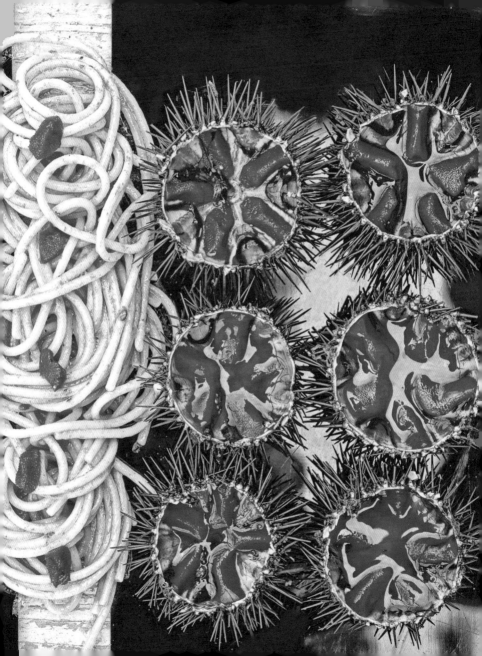

PASTA WITH CHICKPEAS

■ ■ ◻

Serves 4:
- 400g (14 oz) fresh tagliatelle pasta
- 300g (10¹/₂ oz) chickpeas
- 1 onion
- 1 celery
- 1 carrot
- 1 peeled tomato
- a few Italian parsley leaves
- extra virgin olive oil
- salt
- pepper

Soak the beans overnight in water with a handful of salt.

Cook the chickpeas in cold water. As soon as the water boils, transfer the chickpeas to a saucepan with the vegetables and fully cover with water.

Boil three quarters of the tagliatelle until *al dente*.

At the same time, fry the remaining tagliatelle in a frying pan with oil until golden brown.

Combine the fried and boiled pasta, stir in the chickpeas, adding the cooking oil and a sprinkling of pepper.

Girofle
Salento IGT Rosato
Azienda Monaci,
Copertino (Lecce)

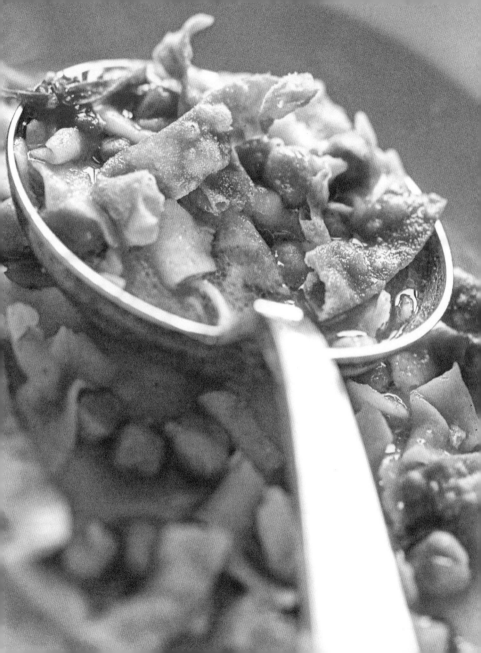

■ ■ ◻

Serves 4:
- 400g (2 cups) dried fava beans
- 600g (1⅓ lbs) wild chicory
- 50g (1¾ oz) celery
- 50g (1¾ oz) onions
- 50g (1¾ oz) carrot
- garlic
- bay leaf
- chilli pepper
- 200g (7 oz) good bread
- extra virgin olive oil
- salt
- pepper

FAVA BEANS AND CHICORY

Soak the dried beans the day before.

The next morning, cook the beans in an earthenware pot with the celery, carrot, onion, garlic, bay leaves, olive oil, salt and pepper.

When cooked, remove the vegetables and herbs, and blend the beans until creamy.

Clean the chicory and boil in salted water for 3 minutes. Drain and allow to cool.

Sauté the vegetables in a pan with olive oil, garlic and chilli.

In a serving bowl, place the chicory on the pureed beans, adding the previously toasted bread.

Season with plenty of olive oil.

Tempio di Giano
Salento IGT Rosso
Cantine Vetrere,
Montemesola
(Taranto)

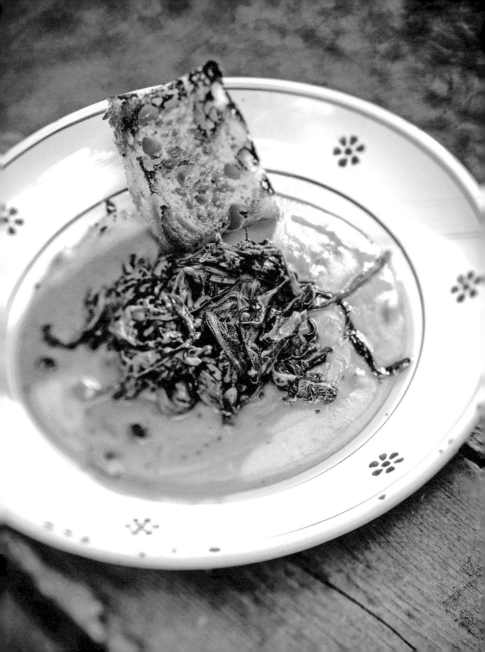

AUBERGINE PARMIGIANA

Serves 4:
- 4 medium
 aubergines
- 2 x 125g (4½ oz)
 mozzarella cheese
- basic tomato sauce
- 2 eggs
- 100g (½ cup)
 Parmesan or
 pecorino cheese,
 grated
- basil
- flour
- extra virgin olive oil
- salt

Slice the aubergines, sprinkle with salt and leave for a few hours until they have released their bitter liquid.

Dry the aubergines, dip in the flour then in the beaten eggs, and fry in ample hot oil.

Drain the aubergines and arrange them in a baking dish in alternating layers of tomato sauce, basil, sliced mozzarella, the grated cheese and any other ingredients you may care to add (e.g. diced ham), covering the last layer with plenty of tomato sauce.

Bake at 160°C (320°F) for about ten minutes or until the mozzarella has melted and a crust has formed.

Donna Cecilia
Daunia IGT Rosso
Azienda agricola
Sergio Grasso,
Lucera (Foggia)

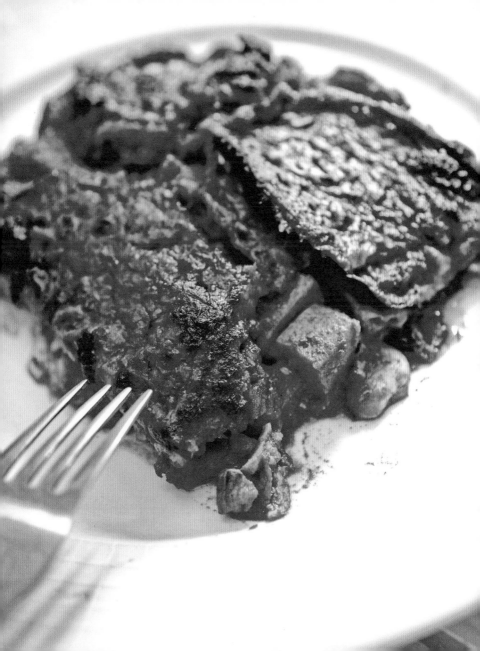

■ ■ ◻

Serves 4:
- 300g (3 cups) flour
- 400g (14 oz) mixed
 vegetables (squash
 shoots, cherry
 tomatoes, silverbeet,
 escarole)
- 2 garlic cloves
- chilli pepper
- 125ml ($1/2$ cup) extra
 virgin olive oil
- salt

FUSILLI PASTA WITH VEGETABLE SAUCE

Mix the flour with lukewarm water to form a soft, smooth dough.

Form 3cm long thin strips of the dough. Using a knitting needle, roll each strip into a spiral shape.

Soften the garlic in a pan with the oil and add the halved tomatoes.

Boil the vegetables in ample salted water.

When half cooked, add the fusilli.

When cooked, drain the pasta and vegetables, and sauté everything in the pan with the sauce, adding the chilli.

Sogno di Volpe
San Severo DOC
Rosato - Cantina
Ariano, San Severo
(Foggia)

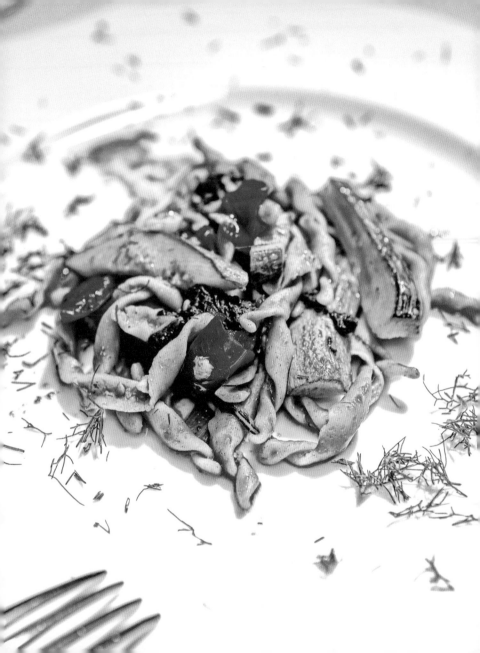

BAKED PASTA

Serves 4:
- 400g (14 oz) short pasta of your choice (penne or rigatoni)
- 300g (10½ oz) ground beef
- 1kg (2 ¼ lbs) tomato purée
- 1 egg
- 2 x 125g (4½ oz) mozzarella cheeses
- ½ onion
- a few basil leaves
- 150g (5¼ oz) sliced ham
- 200g (1¾ cups) grated pecorino cheese
- extra virgin olive oil
- salt
- pepper

Mix the meat with the egg and 100g (¾cup) of cheese, seasoning with salt and pepper.

Shape into small meatballs and quickly fry in hot oil.

Make a sauce by adding the tomato to the onion fried in olive oil. Add salt.

Cook the pasta in salted water until *al dente*. Drain and mix with a ladle of the sauce.

Place in a baking dish, making alternating layers of pasta, sauce, mozzarella, ham, the remaining cheese, meatballs and basil leaves. If desired, top with sliced tomato.

Bake at 180°C (350°F) for approximately 10–15 minutes.

Alberelli De La Santa
Salento IGT Rosato
Cooperativa Terre di
Puglia-Libera Terra,
Mesagne (Brindisi)

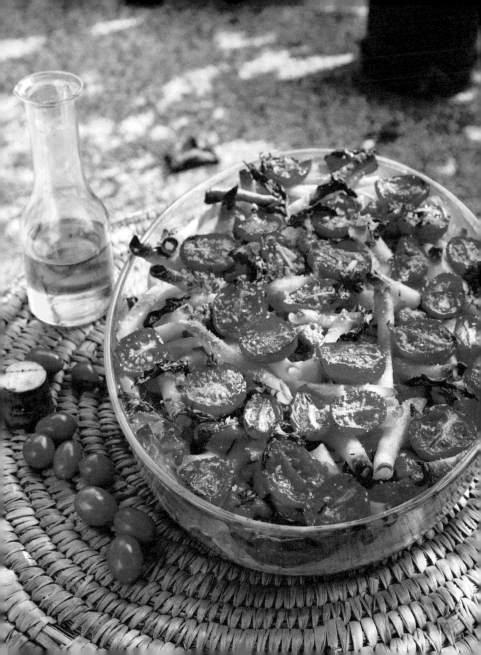

Serves 4:
- 400g (14 oz) spaghetti
- 1.2kg (2 ²/₃ lbs) mussels
- 1 garlic clove
- oregano
- Italian parsley
- 1 dash white wine
- extra virgin olive oil
- pepper

SPAGHETTI WITH MUSSELS AND OIL

Thoroughly clean the mussels. Remove the meat and set aside with the strained liquor.

Soften the garlic in the oil and add the pepper, oregano, chopped parsley, a dash of wine and then the shelled mussels.

Boil the spaghetti in water with little or no salt. When cooked, combine with the mussels.

Greco
Puglia IGT Bianco
Cantina Casaltrinità,
Trinitapoli (Foggia)

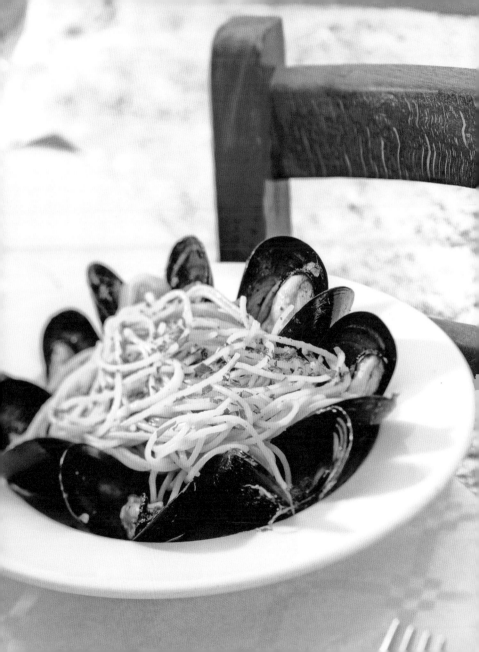

OVEN-BAKED RICE, POTATOES AND MUSSELS

Serves 4:
- 1kg (2¼ lbs) mussels
- 500g (1 lb) potatoes
- 300g (1½ cups) rice
- 500g (1 lb) red tomatoes
- 2 courgettes
- 2 onions
- a few basil leaves
- 1 handful grated pecorino cheese
- extra virgin olive oil
- salt
- pepper

Using a high-sided baking dish, preferably earthenware, make a layer of thinly sliced onion, a layer of courgettes sliced into rings, then a layer of sliced potato.

Wash the mussels thoroughly. Open, discard the upper shell and retain the liquid.

Make a layer of mussels on the vegetables then a layer of rice. Cover with the strained liquid from the mussels.

Finish with a layer of sliced tomatoes, one of courgettes and one of onion.

Sprinkle with a handful of pecorino cheese, add a few basil leaves and drizzle with oil.

Bake at 190°C (370°F) for 45 minutes. Serve hot or cold.

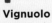

Vignuolo
Castel del Monte DOC
Rosato
Cantine Vignuolo,
Andria

'BURNT WHEAT' ORECCHIETTE PASTA WITH COURGETTE TOPS

Serves 4:
- 200g (7 oz)
 orecchiette di grano
 arso pasta
- 500g (1 lb) tender
 courgette leaves
 and shoots
- 2 garlic cloves
- aged sheep's milk
 ricotta cheese
- extra virgin olive oil
- salt

Clean the courgettes, choosing the most tender parts and the smallest leaves (the filaments should be removed from the larger leaves).

Cook the vegetables in ample salted water.

When cooked, place the orecchiette pasta in the same pot.

In a pan, fry the garlic in oil until soft.

When the orecchiette are almost cooked, drain everything and sauté well in a pan with the garlic and oil to the point that almost a cream forms.

Serve with grated aged ricotta.

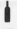

Vigna Pedale
Castel del Monte
DOC Rosso - Cantine
Torrevento, Corato
(Bari)

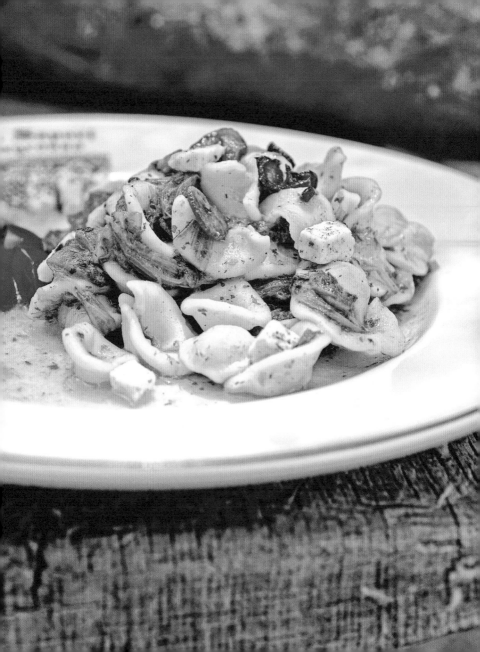

SECOND COURSES

ALTA MURGIA SAUSAGES

■ ◻ ◻

Serves 4:
- 500g (1 lb) Alta Murgia 'Punta di Coltello' sausages
- 1 glass dry white wine
- 1 sprig rosemary
- extra virgin olive oil
- salt

Grease a baking tray and roast the sausages with a sprig of rosemary at 180°C (360°F) for 30 minutes.

Halfway through cooking, sprinkle the sausages with the dry white wine and lightly salt.

Vigna del Melograno
Castel del Monte DOC Rosso - Azienda agricola Santa Lucia, Corato (Bari)

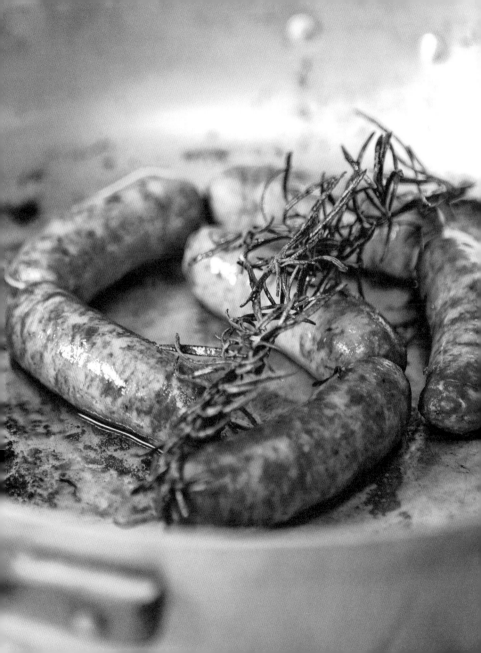

HORSEMEAT ROULADES WITH SAUCE

Serves 4:
- 800g (1³/₄ lbs) horse rump steak cut into 8 slices
- 1kg (4 cups) tomato purée
- 100g (1 cup) pecorino cheese, grated
- 50g (¹/₄ cup) capers
- 1 bunch Italian parsley
- 1 garlic clove
- 1 glass red wine
- 125ml (¹/₂ cup) extra virgin olive oil
- salt
- pepper

Tenderize the meat slices and top with the capers, parsley, pecorino and a sprinkle of pepper.

Roll the slices and close with toothpicks.

In a saucepan, fry the meat in oil with the garlic. Add the wine and allow to evaporate.

Add the tomato purée and salt, and cook for at least 3 hours, adding a little water.

Amativo
Salento IGT Rosso
Cantine Cantele,
Guagnano (Lecce)

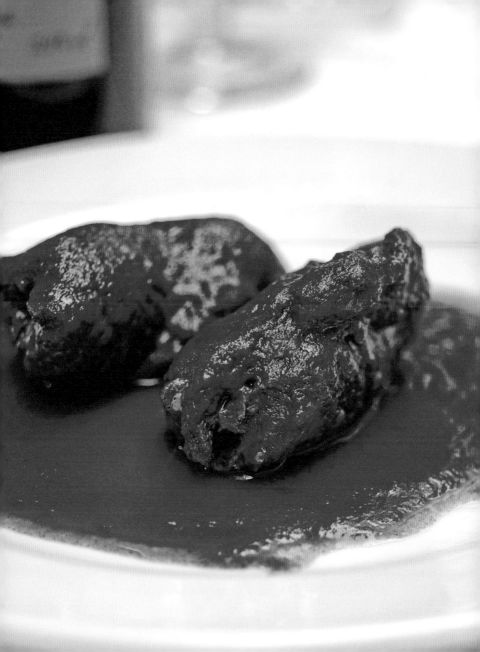

LAYERED ROAST LAMB AND POTATOES

Serves 4:
- 1.2 kg (2²/₃ lbs) lamb pieces
- 1kg (2¹/₄ lbs) potatoes
- 3 garlic cloves
- breadcrumbs
- extra virgin olive oil
- salt
- pepper

Place the lamb pieces, and the peeled and sliced potatoes in a well-oiled earthenware pot.

Sprinkle with plenty of breadcrumbs and minced garlic, and season with salt and pepper.

Sprinkle with olive oil and add ¹/₂ cup of water.

Roast at 180°C (360°F) for approximately 45 minutes.

Terragnolo
Salento IGT Rosso
Casa vinicola
Apollonio, Monteroni
di Lecce (Lecce)

■ ■ ▢

Serves 4:
- 1 x 1kg (2 $\frac{1}{4}$ lbs)
 octopus cleaned,
 tenderized and
 washed
- 1 onion
- 3 tomatoes
- 1 bunch Italian
 parsley
- 1 bay leaf
- 1 garlic clove
- extra virgin olive
 oil
- pepper

OCTOPUS IN EARTHENWARE

Place the whole octopus in an earthenware pot with the chopped tomatoes, sliced onion, garlic, chopped parsley, bay leaf and pepper.

Sprinkle with oil, cover and cook for approximately 2 hours.

Ponte della Lama
Puglia IGT Rosato
Cantine Cefalicchio,
Canosa di Puglia

OCTOPUS SALAD WITH GREEN BEANS AND POTATOES

Place the octopus in cold water in a pan and cook for at least 35 minutes.

When cooked, remove from the water and allow to cool on a plate.

Separately, steam or boil in salted water the green beans and potatoes. Drain and allow to cool.

Cut the octopus and vegetables into small pieces, and place in a salad bowl.

Season with salt, lemon juice, oil, pepper, minced garlic, peppermint leaves and grated lemon rind.

Serve at room temperature.

Serves 4:
- 700g (1½ lbs) octopus
- 3 medium potatoes
- 300g (10½ oz) green beans
- 1 lemon
- 1 garlic clove
- a few peppermint leaves
- extra virgin olive oil
- salt
- pepper

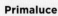

Primaluce
Castel del Monte
DOC Rosato - Cantine
Carpentiere, Corato
(Bari)

Serves 4:
- 2 squid
- 4 prawns
- 1 large or 4 small
 rose fish
- 2 fillets grouper
- 1 fillet oily fish
- 1 angler
- mussels
- 2 onions
- 1 garlic clove
- 10 cherry tomatoes
- Italian parsley
- a few bay leaves
- dry white wine
- extra virgin olive oil
- salt
- pepper

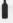

Sessantanni
Primitivo di Manduria
DOC - Cantine Feudi
di San Marzano,
San Marzano di San
Giuseppe (Taranto)

FISH SOUP GALLIPOLI STYLE

Thoroughly clean the fish, prawns and mussels. Cut the squid in half.

Fry the garlic and sliced onions in oil for a few minutes.

Add all the fish and splash on a little wine.

Let the wine evaporate then add the tomatoes.

Season with salt and pepper.
Add the chopped parsley and bay leaves.

Cook for approximately 20 minutes over a medium heat.

Serve with toasted bread and sprinkled with a handful of Italian parsley.

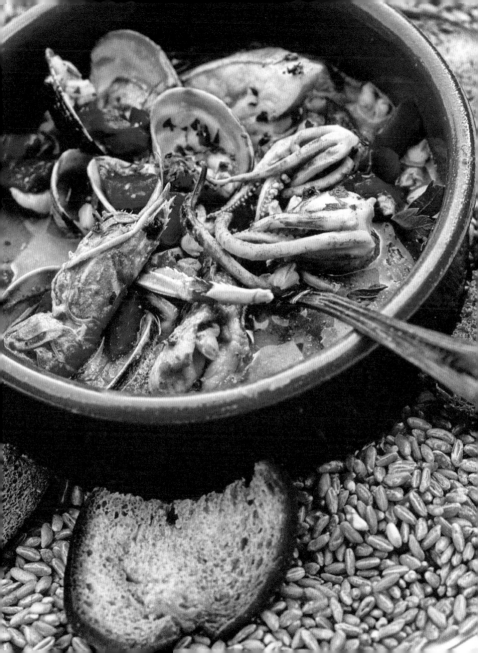

MUSSELS AU GRATIN

Serves 4:
- 1kg (2$^1/_4$ lbs) mussels
- 100g ($^3/_4$ cup) breadcrumbs
- 50g ($^1/_4$ cup) Grana cheese, grated
- 1 clove garlic, minced
- 1 bunch Italian parsley, chopped
- oregano
- extra virgin olive oil
- pepper

Thoroughly clean the mussels, discarding the top shell, and place in a baking dish.

Prepare a very fine mixture of breadcrumbs, cheese, pepper, oregano, garlic, parsley and a little oil.

Mix thoroughly and top the mussels with the mixture.

Bake at 200°C (390°F) for approximately 5 minutes and serve hot.

Cantalupi
Salice Salentino DOC
Bianco - Cantine
Conti Zecca, Leverano
(Lecce)

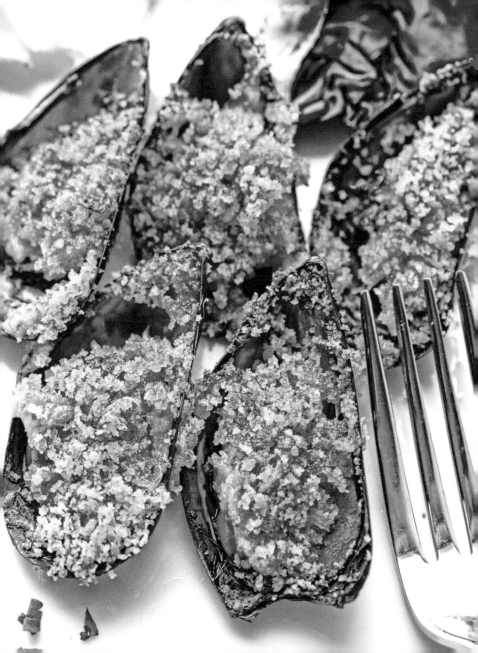

STUFFED PEPPERS

■ ■ ☐

Serves 4:
- 4 medium peppers
- 400g (14 oz) minced veal
- bread with crusts removed
- milk
- 1 egg
- 70g (²/₃ cup) pecorino cheese, grated
- a few capers
- 1 garlic clove
- Italian parsley
- extra virgin olive oil
- salt
- pepper

In a bowl, combine the meat, egg, bread (previously soaked in milk), pecorino cheese, a few chopped capers, the parsley chopped with the garlic, salt and pepper.

Cut the peppers near the stem and remove the seeds.

When the filling is soft and damp, stuff the peppers.

Arrange the peppers in a baking dish and sprinkle with oil. Bake at 180°C (360°F) for approximately 20 minutes.

Zaniah
Puglia IGT Rosso
Cantine Polvanera,
Gioia del Colle (Bari)

DESSERT

DRIED FIGS

Ingredients:
- white figs
- toasted almonds
- lemon zest (optional)
- chocolate (optional)
- bay leaves
- fennel seeds

Leave whole ripe figs in the sun for approximately a week on a fruit drying rack. Keep covered with cheese cloth or fine netting and turn frequently.

Once dried, blanch for a few seconds, drain and allow to dry on a towel.

Slice lengthways from the base of the stalk, without separating the two halves, and stuff each with a toasted almond and, if desired, a little lemon zest and chocolate.

Close and place in the oven at 220°C (430°F) for approximately 30 minutes.

Place in glass or earthenware jars with fennel seeds and bay leaves.

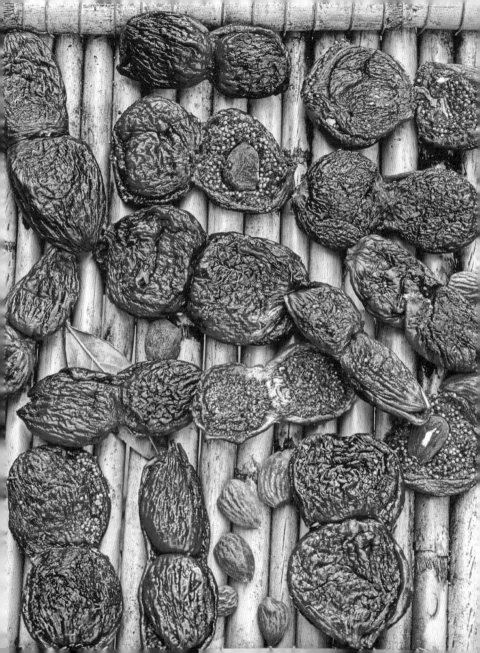

CARTEDDHATE

■ ■ ■

Ingredients:
- 1kg (2¹/₄ lbs) white flour
- 200ml (³/₄ cup) white wine
- extra virgin olive oil
- grape vincotto
- coloured comfits

Sprinkle the flour on a flat surface and knead with 250ml (1 cup) of olive oil and the wine. Add water as needed to produce a dough of medium consistency.

Divide the dough into smaller portions and roll into very thin circles.

Using a fluted pastry wheel, cut strips of approximately 4cm in width and approximately 20-30cm in length.

Fold each strip over on itself lengthways and form into a nest shape, pressing with your fingers every 3-4cm.

Allow to dry for at least 12 hours, then fry in hot oil.

Drain then submerge in the boiling vincotto (or in honey).

As soon as they float to the surface, remove and arrange on a plate. Sprinkle with the coloured comfits.

Il Sava
Primitivo di Manduria
DOC Dolce Naturale
Vinicola Savese, Sava
(Taranto)

SWEET BISCUITS

Ingredients:
- 600g (4 cups) 00 flour
- 4 eggs
- 4 tbsps Marsala
- 100g ($^1/_2$ cup) sugar
- 4 tbsps extra virgin olive oil
- salt

Mix the flour with the eggs, a pinch of salt, the sugar, oil and Marsala to form a solid dough.

Divide into smaller pieces and form into approximately 15cm long rolls. Join the ends to form rings.

Drop into abundant lightly salted boiling water.

Remove as soon as they float to the surface and place on a lightly oiled baking pan.

Bake in a hot oven for approximately 20–25 minutes.

In Nomine Patris
Puglia IGT Passito
Selezioni Acquario,
Trani

ALMOND CAKE

■ ■ ◻

Serves 4:
- 250g (1½ cups) peeled almonds
- 200g (1 cup) sugar
- 6 egg yolks
- 3 egg whites
- 1 lemon peel
- butter

Grind the almonds with the sugar to a fine flour.

Put the mixture in a pan with cup of cold water. While constantly stirring, heat for approximately 10 minutes.

Turn off the heat and wait for the mixture to cool. Then add the grated lemon zest and egg yolks.

Beat the egg whites until stiff and add to the mixture.

Mix well and pour into a buttered baking pan.

Bake at 180°C (360°F) for approximately 30 minutes.

Moscato di Trani
Trani DOC Moscato
Cantine Botta, Trani

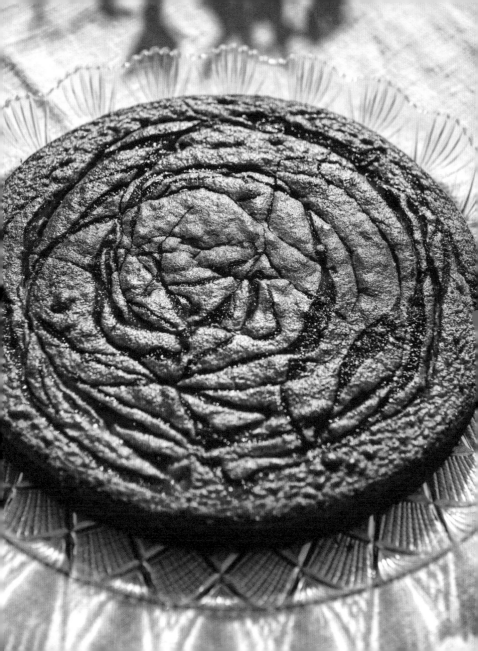

CEGLIE MESSAPICA-STYLE BISCUITS

Serves 4:
- 500g (3 cups) almonds
- a dozen bitter almonds
- 200g (1 cup) sugar
- 4 eggs
- 2 tablespoons Strega liqueur
- 1 lemon zest, grated
- black cherry jam

Peel and roast the almonds, then crush on a hard surface with a glass bottle.

Add the sugar, lemon zest, liqueur and whole eggs, and combine to form a solid dough.

Using your fingers, squash and stretch the dough on a pastry board to reduce its thickness to approximately 4cm.

Put the jam in the middle and fold the dough over on itself.

Cut into small squares of approximately 4x4cm.

Oil a baking tray and sprinkle with flour. Place the biscuits on it and bake at 180°C (360°F) for 5 approximately minutes.

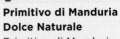

Primitivo di Manduria Dolce Naturale
Primitivo di Manduria DOC - Cantine Attanasio, Manduria (Taranto)

GLOSSARY

Acquasale (cialledda)
Moistened old bread seasoned with tomato, olive oil and salt, sometimes served with sliced cucumber and red onion.

Burrata
Fresh cow's milk cheese ball with a stretched curd and cream heart, and a stretched curd covering.

Caciocavallo
Pear-shaped semi-hard stretched curd cow's milk cheese with flavour ranging from delicate to spicy. Variety: caciocavallo podolico dauno.

Cacioricotta
Cylindrical fresh cheese made from sheep's or goat's milk, or both, with a delicate flavour. Aged, it's ideal for grating on first courses

Carteddhate
Traditional Christmas cake, made from strips of fried dough in the shape of a nest, filled with vincotto and honey.

Cavatelli
A thin fresh or dried pasta, rolled with the fingers to form a cavity.

Cialledda
Local variant of acquasale (→).

Fedda rosse
Bari variant of frisella (→) with tomato.

Frisella (Barley bread)
Hard bread ring made of barley or wheat,

which is smooth on one side and rough on the other.

Giuncata
Cylindrical or rectangular fresh cheese made from cow's, sheep's or goat's milk, with a very soft, delicate texture.

Grano arso
Roasted and ground durum wheat, once made by grinding grains collected after burning stubble.

Manteca
Pear-shaped stretched curd cheese with a butter heart.

Mozzarella
Fresh stretched curd cow's milk cheese made in large and small balls, braids and knots, with a slightly tart flavour.

Orecchiette
Fresh or dried pasta shaped like small indented disks.

Panzerotto
Fried pocket of dough stuffed with mozzarella and tomato or other ingredients as desired.

Pignata (Pignatta)
Earthenware pot used to cook meat, fish or legumes.

Pìttule (Pettole)
Leavened dough fritters sprinkled with sugar. A savoury version is made with salted cod,

anchovies or cauliflower added to the dough.
Puccia
Round bread typical of the Lecce area.
Ricotta
Fresh cheese made from the whey of cow's,
sheep's or goat's milk, or a mixture, with
a delicate flavour. Variant: ricotta forte
('skuant): A soft, creamy and spreadable
version with a spicy flavour.
Sagne 'ncannulate
Fresh or dried pasta like twisted lasagna
sheets.
Scaldatelli
Long taralli (→) typical of the Foggia area,
flavoured with fennel or pepper, onion and
chilli pepper.
Scapece
Dish using fish that is fried and then
marinated.
Sgagliozze
Cubes of polenta fried in oil, typical of Old
Bari.
Strascinate
Type of pasta similar to orecchiette (→) pasta,
but flatter.
Taralli
Crisp bread rings made with soft-wheat flour,
olive oil and white wine, and flavoured with
spices – generally fennel seeds.

Tiella (Taieddha)
Originally the name of an oven dish but now used
to describe dishes in which the ingredients are
layered (e.g. tiella of rice, potatoes and mussels,
or tiella of lamb and potatoes).
Tria
Salento variant of tagliatelle.
Troccoli
Fresh pasta in the shape of thick spaghetti,
30–40cm in length, typical of the Foggia area.
Turcinieddhi (o gnumarieddhi)
Lamb and goat offal (heart, liver, spleen, lungs)
wrapped in intestines with herbs. Grilled.
Uliata
Puccia (→) with olives mixed into the dough.

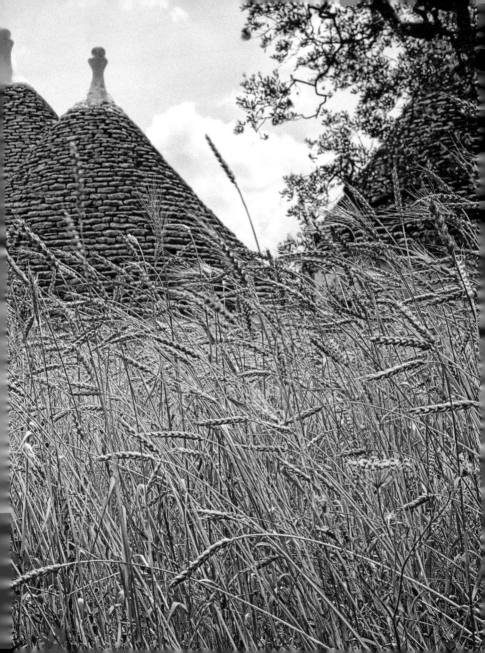

Recipes by
Vittoria Ceci, Titta Gramegna, Angelo Silibello, Cosimo Tricarico, Pietro Zito, Peppe Zullo
Editing
William Dello Russo
Translation
Chris Turner
Photoeditor
Giovanni Simeone
Layout
Jenny Biffis
Prepress
Fabio Mascanzoni

Special thanks are due to **Nicola Campanile**
(www.radicidelsud.com) for his precious
consultancy in the selection of wines.

IV Edition 2019
ISBN 978-88-95218-30-4

Distributed by Atiesse Rappresentanze
T. +39 091 6143954
www.simebooks.com

This book is an excerpt of:

"PUGLIA IN CUCINA
THE FLAVOURS OF APULIA"

80 ricette della tradizione (e non)
80 traditional and non-traditional recipes

Recipes by Vittoria Ceci, Titta Gramegna, Angelo
Silibello, Cosimo Tricarico, Pietro Zito, Peppe Zullo
Photographs by Colin Dutton

Hardback
Italiano/English
288 pages
19,5 x 23,5 cm
ISBN 978-88-95218-19-9

www.simebooks.com